Brains and actions....

Crimes will give us biggest troubles.

Something comes are life are bubbles.

Yeasts are good are acts of bibles.

Family jewels all are marbles.

Buy by skies and clouds are waving.

Brains have banks are large are saving.

Psyche masses are massive making.

Psychic senses are functions mapping.

Who will own our skies are coming.

Those are coming theaters hunting.

Hunts you peoples get as casting.

Themes are good and not for asking.

Not as spells and all are liars.

Science comes and some with liking.

Signs of auras are trance dying.

Cliff effects-Essay….

Cliff effects all are careerism falls. Snobbish mocks are good for offices calls. Cruel forces are good for bossy modes. Call your name and dig your wills. Who fawn a lot would be fine. Franking stamps are long to seal. Tiger accords are army war devices and wares. Sexes to call are offices calls Secret agents are masochism sexy calls. Ask for helps for human powers all are army hosts. Come and move you will account for fiddles good by laws and forces. Stir up troubles all are mischief made. Come to get related to bosses are T.V. girls. Come to get related to chiefs are jester able. Laws hassles all are raw. Hasidism only prey but not to learn and get researched. China jesters only fawn and not to know about our peoples rights. Christian Aid will help. China jester mocks will harm. Cliff effects are to go high in poses but push you near the cliffs. German Christian Democrat Aid with social welfares to German peoples. China jesters take their bribes as feels at spoons. BOUTY is china tyrants

ESSAY-(all)....

All my favor critical theorems on faiths are conditional stimulus by come on ways. Our belief is weak or strong are chances of conditional reflexes. All my favor points to criticize china commie is life.

China kills.

Maoism kills.

WUJANTO kills.

Tyrants kill.

Dream of mine is ghosts but nothing gods. Dreams of tyrants all are odds. Dreams of tyrants all are hosts. Tyrants pick it up are dreams of godlike powers and forces. Painful pains to peoples much are much.

More strong would be desires for more with wealth, possessions, or self esteems or comforts or powers.

More in minds than bodies can have as such.

Logic illicit and moral hazards are easy to come.

What a toady to gods is not what a toady to bosses as over lords.

Essay-beaten paths...

Scorching earth is nuke in forces but natures should also aware. Beaten path is wars and mongers. China tyrant toke their constant intends is worse. Ignore our ways but rights are good and we are tosses in dreams.

Forces are too many. China whites and poppy flowers are too many. Offer all you have had. Or keep your consciences now. Some defects and bad as drugs and poison pushers are clear. Think a lot of laws may good. They are shame. They wet behinds their ears for long. Hacks and coughs are worlds greeting. Use a pill that harm is foolish until their medical reasons. Heaven courses are bad to march. China tyrants said a lot for anti crimes. Talks are big but need to take. WUJANTO babe kisser kissed.

Soldier right is rampages. China tyrant runs amok and kills. Ramshackle pales and jelly built are some china bribes of housing affairs. Their very fates are bad for WUJANTO and china heresy political party controls.

Essay-bossy bosses..

Self examine come to meet our commie ways. Just for dictations meet their tyrant ways. Who is boss, that bossy comes. What is force that souls are called?

Red is red are active strength that wet. Moist is damp and bloods are fluid that wet.

Muggy men have worships to tyrant heats.

China heats will raise or sink as base.

China battle arrays will lineup.

Outfoxed all are tactic forms.

Like a spasm we bow and sob to china tyrants.

Powers seeking all are CLONIC spasms.

Wars and battles pitches will come to mud.

Some removed as dust are soldier men.

Can we live in peace with no oracles warns.

China banishes men with democrat thoughts or sent them to jails for many years.

Gifts of wars are all are spoils.

China powers centralism all and have orbits.

Essay-china dances...

PINKO fights for world dominations all alike a thief. Red for dominatrix takes the gifts of worlds. Boots are old and hands are heavy. Upper hands are commie take as choice. Domino theorems take away something right. However what domino was our Uncle Sam can still as right as good to help the Taiwan. Who can forget the pains once there are faiths for human rights and freedom uprights that are so precious all are our value cores. Who can forget the pains once troubles are waiting? China red dominatrix is reds to our worlds and waiting forcefully. Some as commie proclaims a very bad sign.

Laws are dances that need our themes and beats. Themes will give you minds and senses of prides. Dance is upright moves. PINKO dances are tricks to move your vanities hearts. Play it forcefully but not so fair. PROCRUSTEAN china commie rules by laws and forces. Forces are firsts and laws are tyrant wills. Cut with

Essay-festers..

For ascetic life is stoicism stock. Forbid fruits are not to bail. Sexes and feasts are not pleasures functions. Index to life is knowledge and scripts. Confined places are duke of lucks. Office bosses that work in flying buildings are no more always. For a broken life has broken assets. Scourge of nations all evil whips of single china party that whip. Evil minds are gods to double cross. Curses our ways are tombs with roses. Who will buy our words and stocks? Roots of troubles come from forces. FRIENDLIE five has fuzz and dreams. Evil dragons mark our china state. Fuzzy logic takes as brains. Some effects are special made. But all morals and jobs are half measures. Worse as festers come from tyrants forces. Soggy biscuits eat and lead the evil gangs. Soggy bisque white is sperms. Bistro treats have buy and sell. Bistro effects just as bribes are china polices. Buy you and sell you as you are right. China little parts are jesters' bits. China little bits will play no game. China timer nabob life

Essay-flowery hearts…

Flowery words are flowery hearts. However some exceed the proper margins in righting wrong. Over does are strict are stiff and bad. Jails for words are tyrants none restrained. Examine our new and search for cover means are drop to hells. Most are facts are front and back. Some affected in manners all with charm offense. Hypothetical images have better predictions but need our hints or cues. Link

Essay-ideology...

Human teased by games and fates. Tyrants tease us by hopes and greed. Tyrant dreams are dreams of over lords.

Gifts they give are midnight mares. Tyrants weapons keep as nukes China nukes are quantum leaps of atom nuts.

Tarred with same brushes are also there are men of the same inks. Tangled ways are tangled loves.

Tangled laws are shysters shy no ways.

China ordinate 23 is bad to people freedoms.

Extra ways are please and comforts of china tyrants.

Take a vote that put a vote must need. Turn and move are curves to other worlds. Must you

Get the moral codes with moral fibers. Must you get moral codes as better symbols!. Laws have conventions are too flexible for differ one.

Taoist magic figures are spells them drinks and breads thought buying or selling status, josses, cense, or doing

Essay-laws and earth..

Legal concepts come as wheels. It run around is god very heels. Corporate personality is well. Legal entity may be self. Self with principle just are rights.
Some interpreted laws are careful cases.
Funny farms are permitted as special case.
Views reserve comes are funny counts.
Privileged stratums classes are very grand and smart.
Off our centers just are jesters ways.
Special pardons give to bad noble man.
'Decree of special pardon some are rich device.
Bribe your doctors who doctor all health reports.
Karma sutra all has points and steps.
What come as smaller parts may change the whole.
Once in HONG KONG a rich whose wife is entitled woman, he get the special pardon from British queen for health reason. He is suppose to die within week but from that time and many years as facts he is live more than twenty years and in 2012 he still alive.

Essay-laws..

Strictly prevent are people ways. All dissenting views are treat by suppress forces. China tyrant forces squeeze and treated many social faces. Brains are washed by conditional stimulus. Peoples strive for best as may be aim. So our people ways are country cultures.

China utilitarianism constants are china fierce winds that blow. Like Spanish fiestas china worships tyrant days. Laws of America steps are unified fields. Sui Men had said that our world in whole was one unit. All is one is all is public not pubic with camel toes.

Laws and pizza may be good as GALILEO. Also units of Henry all will need the coils. So for china all for better morals than all are holly oils. China did do something good and charge our worlds as nothing bad. Please let just nothing drift as all may good for peoples..

---------Cheung Shun Sang=Cauchy3-----------

Essay-push and acts!..

Political Iconology seized their maps.

China ways of function is operated wrong.

Land forfeits cause by China sins.

Forges a heads for law are crimes of men.

Properly plans are cautions courses.

Places to put are scenic spots.

Turned out with strengths are dictated ways.

Topple china made and keel and over may be true.

Icon marks of policy are iconoclast politic.

Who believe to rationalize olden themes?

Love your nations just not to harm the ways of worlds.

Cause by crime your land forfeit must be right.

China leaders iconize are bad and fault.

People iconoclasts are good to counter iconize china political status.

China land forfeit must be right.

Some china iconoclasts with political ways sink the heats and alter china tyrant ways.

Essay-tough..

Sampled impressions all are rationalized as reasons deals.

China leaders rationalized killing movies are orders or just kill for kills. NOT TO OFFEND OUR MIGHTY LAWS. We kick the clouds as there are gallows. We shock and our hearts may fail to beat as there are non-mercy chairs.

However powers to all peoples must be ought Beaucoup beauty might sell their souls. All due diligences must be weak. Strong and fierce in wills are tyrant ways. Tyrant troupers show off their ways. Have a bellyful of tricks are something that hide are facts. Best regards to esteem leaders are powers and possessions. Modern jester trousseau is tricks that hide. Modern women trousseau is her fetus. PINKO wombs are evil mothers.

Mental spent are minds that tangle. Hearts that fail is weak in cardiac cycles. Tyrants ZOIC-cycles all are tough.

Essay-words to china...

China procrustean take you worse.

Come from Greek robbers take as china king courses.

China predators use the feeble men and weak as people kowtow knees.

Yes to them or you may be stirred. Some regards with mercy all are faked. China shame to china sutra words that list on book but reply is china rooms.

Better features all are very bad as charms offense.

Tailor made WUJANTO but cruel inn heart.

All are such with dictates rules and demagogues plugs or jacks. Some electricity fields are evil charges. Quantum works are efforts to make their wrong. Wrong to worlds and drum at America all is at once.

Must decline are tyrants ways of measure that offer as mighty commie party.

Trends of events all may lay their hands. Trends of events also some finances make the tyrants band

Heat..

Heats will change to smokes that coil.

Satan uses no holly oils.

Belly full are dirty tricks.

Spilt to you are you are wicked.

Get as nowhere all are spaces.

Some devout are cards of ace.

Nothing gambled all have lucks.

Keep your faces will mad as nuts.

Smart as you is babe breath.

Condemn you are views are best.

Breathes will down to necks as see.

China tyrant counts are sins.

China tyrant forces may keep.

Honest men have fires to eat.

Heats not sink and sins not good.

Keep...

Timid shy and nerves are weak.

Queer are bosses our chiefs are freak.

Queer to think are tyrants laws.

Strange are ways are something maw.

Straight to think are tyrants how.

China tyrant does the now.

Now to conquer all are marred.

Little fishes are foods of sharks.

Top of totem all are tops.

Tops of charts will eat a lot.

Keep your words so safe not jails.

ZOIC-worlds are sick or ail.

Maxim words are bible scripts.

Weathers hard are eyes to keep.

Keep a weather eye on all.

Laws sublime..

Army pledges are laws are must.

Army strength is coming masses.

Laws that carry out will due.

Out in post is army real.

Wars that threat will lack the peace.

Snakes will bite and men will kiss.

Best evolve forces is law.

Read my book as not to fall.

Name EXLIBRIS books are fine.

Lunacy ills are foolish times.

World sublimed but need a law.

Martial laws are tyrant saws.

Laws sublimed are very firm.

Laws reformed are better forms.

Mores sublimed are good but rare.

Make…

Steps to take are foods of thoughts.

Glasses are clear are ceiling tops.

Go to schemes a careerist case.

Some attend to laws are base.

All to know from laws are harsh.

Judge our ways but very fast.

Tell our rights from wrong are good.

China tyrants use their moods.

Some accounts to laws are ways.

Buddha ways are moral days.

Make you out are evil takes.

Tyrants take and come and make.

---------Cheung Shun Sang=Cauchy3--------

Merit...

Prediction ways are mental cues.

Cues to get are brains to use.

White or black is right or wrong.

White or brown is fade or strong.

Noises that white are something faded.

Noises that brown are better lay.

Ride a weave is human wars.

Merits all have gains or loss.

Brasses in hats are merits made.

Heats to sink are laws that take.

Calm you down are babe sleep.

Calling no gods that some to meet.

X-files are agent lists that armed.

X-files are weapon wares that hurt.

X-files are merit comes as listed.

Roads…

Some arena takes no laws.

Jargons all are laws that fall.

Settle all are cases are lucks.

Soothe our ways are down and up.

Save our faces are games with facts.

Lift the curfews come to acts.

Get you out is fixes as fixed.

Laws compressed are laws that mix.

Mixed as blesses are very fates.

Very nouns are Darwin says.

Some are red are polar means.

Dreams for peace are best that dream.

Turn and handed are higher forces.

Tyrant forces are spurs to horses.

All are callous all are cold.

Stowaway..

Stowaway needs their rides on seas.

Straight arrows pay their fees.

Tramps will beg for boxes of snacks.

Snail that cook are French that bake.

Bakes to hot is food of French.

Play you songs are groups of bands.

Hider agenda need our moods.

Music good and steaks are good.

Stowaway comes to hide on ships.

Eat and sleeps have begging needs.

Bad accesses are gates to crash.

Poor is sad and things may rash.

---------Cheung Shun Sang=Cauchy3--------

Success...

Urgent comes and wait for dreams.

Dreams have loves and life have means.

Seek your dreams and life is smooth.

Daring men are not to rule.

Ready come and stand for just.

All on edges are laws are much.

Eager men may nothing thing good.

Quick successes are men with moods.

Quick successes are most as urges.

Men with loves have rhymes that nurse.

All unduly loves are poems.

Free your necks are verses to both.

You to me is both is good.

Ways are good but men have moods.

All to hold but some can wait.

Asks and begs is nothing ease-Essay...

Halls of Buddha all are ways are worlds. See and through the vanity worlds with little few illusions. Die to worldly affaires are Buddha life. Human do for what are sometimes favors that depend to others. Do what other like or please. Facial views are lucky boss expressions. See and get insights are tricks or instincts of self that control by our boss or world tyrants. God faces and ways are JANIFORMED also did china despots, Camber talks have camber pots. Beauty faces are rotten skulls, Think so high may put our ways on laws or morals.

Last or less is way of life is life that is willing to sacrifices. Sadden life is sinful souls. Some atone is not to beg but confessed. Some charge can be pardoned. Many but heinous crime that done are serious. Buddha some are nothing sexes but sins to know but offense none. Serve your rights as some retributions come.

A count and a charge is all to each of our men on earth by gods. Death can atone or not atone. Some beyond

www.ingramcontent.com/pod-product-compliance
Lightning Source LLC
Chambersburg PA
CBHW061524180526
45171CB00001B/316